A Gray Realm the Ocean

POETS OUT LOUD

Elisabeth Frost, *series editor*

A Gray Realm
the Ocean

Jennifer Atkinson

Foreword by Patricia Spears Jones

Fordham University Press New York 2022

Fordham University Press has no responsibility for the persistence
or accuracy of URLs for external or third-party Internet websites
referred to in this publication and does not guarantee that
any content on such websites is, or will remain, accurate or
appropriate.

Fordham University Press also publishes its books in a variety of
electronic formats. Some content that appears in print may not be
available in electronic books.

Visit us online at www.fordhampress.com.

Library of Congress Cataloging-in-Publication Data is available.

Printed in the United States of America

24 23 22 5 4 3 2 1

First edition

for Karlyn

Contents

I practiced seeing . . .

—Vija Celmins

I don't know what they mean [by abstraction].
I don't know what they're talking about.

— Jennifer Bartlett

Do women have to be naked to get into the
Met? Less than 5% of the artists in the
Modern Art Sections are women, but 85% of
the nudes are female.

—Guerrilla Girls
(1989 poster)

Foreword *by Patricia Spears Jones*

At the end of "If Orion Is," the poet writes:

> She refused
> to let her fiery
> paint retell
> the hunter's storied
> swagger and sword
> mere illustration mere
> example of
> 'what men are like'

Anyone who has seen the painting "Orion" by Alma Thomas will understand the poet's rendering of fire in this artist's powerful abstraction. And with it, Jennifer Atkinson in *A Gray Realm the Ocean* lets us know what women are like. Women who make paintings, sculpture, and installations. Women who philosophize. Women who create not in the maternal sense but as art makers. Multiple feminine and feminist perspectives in these poems configure a mind alive, and her artists and art works list —which also includes Elizabeth Murray, Chaikia Booker, Pat Steir, Jennifer Bartlett, Ana Mendieta, Amy Sillman, and the British artist Cornelia Parker—is impressive. And with Ms. Parker's work "Cold Dark Matter: An Exploded View" as the catalyst, Atkinson finds a way to rage against American social injustice in the poem "After the Burning of Flood Christian Church in Feguson, MO: An Exploded View."

Atkinson's work is new to me, but I found her commitment to making poems that are part of an extended conversation with these artists, both living and dead, intriguing and provocative. How to address environmental concerns, social injustice and upheaval, female agency—well, in these poems she joins the artists and their works and produces poems that make you re-see works you already know or discover ones you do not.

Her major muse is Agnes Martin, a painter whose spiritual practice helps conceptualize her approach to art, to nature, to

presence and absence. The poem "She Would Not Say Her Work" ends with a Gertrude Steinian echo: "while thinking through snowfall / of roses / of rose of roseness / of not drawing roses." A tender response to Martin's "The Rose."

With this collection, Jennifer Atkinson adds another potent voice to our conversation on art and art makers as she privileges the work and ideas of modern and contemporary women makers for her poetic ends. This seems fitting, as this contest has brought greater attention to a range of women poets.

A Gray Realm the Ocean

Incognita

The underside of the leaf
Cool in shadow
Sublimely unemphatic . . .
—AGNES MARTIN

She is listening beyond the skelter,

skit-scatter notes, the quiver
like a twitched flank under horseflies

—all that loveliness—
cumulous hanks, met glances, rainlights

slurred from the train,
a necklace of unfollowed-up-on impressions, etc.

Listening for what though?

Imagine a pale incognita —
an expanse west of hoister, bluestem prairie

that fire has neither quenched nor tempered

but contained
as if the very ash were kept burning

Remember grade school music class?

The blackboard empty
and not quite evenly gray,

the straight rows,
five by five the fawn-colored

desks, and the teacher affixed
new chalk, five whites in the wooden rake

she drew across the slate plane

erased—after science, after spelling—
unfidgeted even lines

that meant silence

She let us stand on a chair
to loop the clef

if we were quiet

Spirit Level

The lake is an invitation—

A blackboard tipped flat

Chalk clouds and the stray
Half-erased marks of yesterday's lessons

The water as calm as the air

Caught
 in a spirit level—

The surface opens

And after the visible
Membrane heals itself closed

Overhead slow concentric ripples subside

Immersion's
 grainy green-lit silence

Above afloat a charred driftwood moon—

"Night Sea"

 The tideline
is written
 in water in salt
in sand
 what else
but over
 and over
revising
 unknowns
a rhythm
 of unbegun
motion turn
 and return
an authorless
 gesture
the ground is un-
 boundedness gone
over in blue
 in blue
drawn over
 gold leaf
the power of
 squares
like identical
 rhymes
obscured in sameness
 repetition
is self-
 effacement
a widening
 outward
as in the distance
 the sea's
unstillable
 motion stills

Like Somewhere in Saskatchewan

No flower No wind

A crisscrossed field divided as for botanical fieldwork:
A hatched, cross-hatched, half-recovered square

of prairie where every thistle seed
and cricket will be counted,
 accounted for

later in lists and figures, gradations
of madder, the equanimity of numbers

 | | |

Line is a graph of the after-felt, an afterword
thinking back to

milkweed, yarrow, sweet joe-pye,
finches among the high indian grass

In summer walking there
kicks up color—

the uprushed startle of underwings—
and the breathless
 sensation of sky

hits in the thrum and trill

| | |

One bodily moment and its harmonic afterlife:

reverie entered into the record
If the effect is abstract,

it is by virtue of abjuring
for now the plotting of scattered points,
 instances,

loose pollen,
the however beloved details—

She Would Not Say Her Work is the Work of Turning

field to field unless
it were as during

an autumn's early
flurried snowfall when

the grassland's reddish
cast is cast

in new array
The turbulence beyond

the window glass
as if in mind

is arrested. Self-forgetful
as windblown snow

already thawing
to gone

she draws with deliberate
unemphatic certain

lines the sense
while thinking

through snowfall
of roses

of rose of roseness
of not drawing roses

"Lemon Tree"

Tilled snow

Plucked arpeggios

Of reverie rungs

Laddered for zero

The inverse of music

Undelirious lines

Tintoretto's

Unchecked hand

Minus the background

Noise of content

The aftereffect of citrus

Scent and the curious

Dryness left

On your hands

When you pare

The fruit opens

"Milk River"

Even-handed steady at a distance
unlike the Milk or any other river her
lines avoid eddy spill and snag De-
personed denatured the after-image of
riparian green this Milk is an anti-river
Not an abstraction as such Distraction
from suchness is more like it The
picture of riverlit calm How it feels Silt
underfoot eyes closed and undreaming
Swept clean of self

Sufficing

The fragrance of wind across snow

 and the consequent windless

 space of mind

 combed mohair

 (that luster)

 a cicada's scaled wing

 the sphagnum light

 of an April woods

the dust

moonlight leaves or touching

 the green

 luna moth on the screen door

inform her de-nouned line

 Its conviction goes without

her saying

which is to say

 Let and *There is*

Abstraction

A gray realm the ocean belongs to cloud

not this moment's airy hover or scud
—however one may love

mares-tails—the sheen of a mackerel sky—

ice in the distance
doesn't pertain

if one can't overturn the moon

to its dark face
Earth is with form and void

an unvoiced ah or oh

without the ocean's random sounds—
slant rhymes and chance collisions

Is it renunciation

this redoubled certainty?
Is it faith?

One doesn't drift through a narrows

We bound the frayed rope to
an island tree

Reading Nautical Maps

As you trace a finger
from their inland greens and parchment-colored shores

into the barely tinted shallows
where you imagine the great gray heron

wades on its spindly legs, and on out
beyond the farthest low-tide bars inscribed with single-digit

italic depths, you feel the water chill and pressure
grow across the keyed gradations of deep

and deeper blue. The inky depths
surround you. Motionless fish hang like shards

of mirror in the dark, an indigo by now
nearly black. Come to rest

on the ocean bottom, you look up
through the viscous, life-moted atmosphere

to a pallid and faraway surface. Love,
remind me, what is living like?

Here nude as a winkled-out snail,
neither lonely nor lonesome, just

alone, beneath notice, I must have forgotten.
Is it that distant rhythmic crash and fizzle?

"Mountains and Sea"

The broad contours of ocean,

mountain, level shore,
 and the room, a flat expanse

opaque as sky on the floor,
 move in balance.

Place remembered as motion
 —lift, turn, rest—

a muscle memory of days
 in that place seeing.

The landscapes were in my arms as I did it.

Linseed and pine air
 it's an early light—

haloes of blur
 appear unplanned for.

Rose quartz sands
 shift gust-thinned fog,

Atlantic greens and blues,
 salt- and floodtide-scoured.

Some parts are visible,
 some parts not,

the whole 360
 infolded, recalled to form,

a performance of color, collisions
 rehearsed across

the space until it's natural—

"The Bay"

Never not liquid its deep blues
map an alter-Atlantic, an unseen idea

of bay as unlike the actual
body of water as water is like a body.

When the teacher pulled down
her scrolled-up map of the world, no one

mistook its blue wash for land or the pale
yellows and greens—our own state

pink—for the sea. By six, we'd learned
oceans are blue though we knew

in our bodies (we lived by the bay)
the ocean's surface sheen is closer to silver

than sky and inside the waves the water
roils with browns and muddled greens.

A dizzy pummeling otherworld.
This painted bay might be a sea undizzied:

a translation of a translation of turbulence.
Five thousand miles of wind and unbounded

main arrested and framed as a square—
something the size of something

knowable, even known. Except "The Bay" isn't
the bay. It barely references the sea.

Its effect is its subject, more like the lulling
roll of waves out beyond the surf,

your body afloat, loose, looking up,
calm in the vastness, dreaming. The bay

is disappearing inward: wash by wash,
nine Liquitex blues override

the visible to sound the depths of the felt.

'Womb-of-All, Home-of-All, Hearse-of-All Night'

In larval dusk, an early instar of music, blue
emerges indistinct, blooming, barely
audible, un-auroral, into the almost visible spectrum.

The first low sub-indigo note, a pulse,
drones beneath the grays; the smalt-dark swells
with the denser, bass-er scent and ferment of ripe,

ripening, over-ripe fig, color so rich
with interior dark, so gravid with excess itself,
with a lushness bound to stain the very air

with its whelming summer's-end hum
that the sky's transparent skin ruptures.
Incurable now, unstoppable, born:

an ever-so-lightless, so cloud-cauled, so-moon-orphaned night.

A Clear Jar

If you could say it in words—

Low late-summer sun cast over
the wind-flattened salt hay

near the beach where we summered those years

or rose leaves splotched with dried salt
last year's sour hips still stuck in the thorns

or the way fireman's carnival ferris wheel lights
blurred in the humid air that year you turned 14.

If you could say it in words—

the lonesomeness you treasured long and long,
the constant rush and churn of the sea grown loud in the dark,

or the crookedy way a heron flies
or the rocky beach and its arc of rank tidewash.

If you could say it—

the deep, almost-sexual ache in your body when you remember
her voice through the open kitchen window

snatches and half-words where now there is silence.

If you could say *afternoon* and contain in those sounds
a dog bounding through high grass

or *twilight* and hold in its clear jar
the way fireflies cluster and disperse.

If you could say—

White

Under the weight of wet snow
a dead branch broke and fell,

I remember, taking the hornets'
tattered gray lantern down with it.

What if I'd stood the branch
upright in a drift and set the nest

on fire, a moment's torch—orange
mark against the white white air,

a flutter of ash and unburnt shreds
of wasp paper afloat on the flames'

reprieve of lift and lilt. What if
I'd caught a torn bit? What word

might I have written there?

| | |

The body whirs in secret,
a mute hornets' hive:

queen, drone, sting, and a single
blister of hot red honey.

Or *is* it honey? Dare I touch
my tongue to that drop and taste?

How else to speak the hive's fevered silence—
which is to say, how to speak?

| | |

How to contain, to embody, or is it
to dis-embody the whirlwind

of unvoiced desires, powers, counter-
desires, fierce love roiling up,

rising, revving, reveling in
storm-over-the-Michigan light, flashes

nicking the polished sheen of the surface—
and still keep still at the core, wick, theoretical

axis, the scrolled calm this frenzy orbits?
The mind in the midst must stay

cool, undizzied, in order to choose
this stroke not that, while surrounded by winds

as dense as smoke and faintly
sweet in the ozone scorch.

"La Grande Vallée XIII"

Bluer in summer than the doves'
low calls among the trees, evening light

blurs and distorts your vision, as if
through unshed tears or antique

wavery cobalt glass. The valley dreams
itself, lucid and unwakeable—

the moon's white eye taped shut.
Unregarded, you can walk for hours

without speaking. Unaccounted for.

| | | |

I carry my landscapes around with me.
A *Selected* slim enough to fit in a handbag.

How not to love the remembered lake,
replete with loneliness, restive

with secrets and shifting light?

| | | |

In the valley you can wander for hours
alone, meeting no one, singing to yourself

unheard, dropping petals in the stream
to watch them float away. Turtles bask

on flat stones, gold throats exposed to the sun.
Trout glimmer beneath the surface,

translucent fins waving, barely
disturbing a pool's reflections. Shadows

splotched with coreopsis, hawk-bit, devil's paintbrush . . .
Time caught like a twig in an eddy.

Night not yet come down.

"Sunflower III"

Even summer's bronze emblem, burnished and on display,
 might say *enough*—

after its scrabble up from lightless dirt *enough*,
after naïve first yellows, the honeydew shades of light rain
 enough,

after the ripening ochres, the golden corolla and spiraling
 seedhead *enough*—
parched and (yes) weary, *enough*, rustling like parchment in the
 wind.

| | |

"Painting is a way of forgetting oneself"

"Painting is the opposite of death"

| | |

Against the white, muted under encroaching white,
Spectral shadows lean into the blank.

Even after what cast them is gone,
mordant-saddened violet auroras

light the air, the mind—color as legible as language.

Sub-Linguistic Mumbling

Say *peach* and the velveteen pelt slips
from the word's oval, sun-stained body.

From the distance of winter,
 its August almondine,
its leaves' long curls, its fragile April
 Li Po blossoms open.

Call the color *cantaloupe*
and through the rose and orange rush—
 the loam and honey scent—

a half-heard howl
recalls the way a dog reverts
 to wolf to summon sleep,

the way the raw green rind
shows through the melon's flesh,
 the way a song refrains,

looping back and back.
 Description, like translation, is
not so much a rendering
 down or over,

a transfer from real to reflection, field
across to field, as it is a crossing through,

scaring up whatever's alive in June's green or dry November's
gone-by, blowsy weeds,

seeing and hearing into what's there,
 trying not to try,
not to search for—

Imagine pale seeds
 loose in the ripening dark
not-yet-cut-into core,
 run your tongue

along the ridge of little dents and
savor what wells up to fill them—
 nothing like

you'd have thought to taste
in the hollow—*musk melon.*

Interior 1963

Begin with the end and the seed-
syllable *a-*
 men a hem
folded up and pinned

the girl poised
barefoot on the kitchen chair
the mother kneeling
 on a pillow

pins in her mouth
 the pin cushion
an oversized berry too red
stippled with pin-heads and polka dots

the girl is thinking what the tv said
her signature pearls
 peril
horse-drawn the words

riderless and the horses'
long maned heads
 you hold
the reins in one hand to ride

they nail shoes
to the horse's hooves
it doesn't hurt

the woman is eyeing
 the line
is pricking is pinning
the dress to the line

stuck in her head singing
those in peril on
the sea the gray of lead
 in b & w

the little girl is *look*
she looks
 like you
is turning the dress

is another jumper
dark navy to cover
with slimming white

vertical stripes
the girl is turning
 little steps pins
it doesn't hurt

water boils for spaghetti fogs
the window glass
 the girl
is placed is turning

the woman is hemming
 is humming
blue almost black
For those in peril on the sea

If

reverie's blithe invitation arrives,
that hint as of salt on from-afar winds,

you can abandon the sextant will
and depart
 on an unknown inland sea,

unmapped or off-the-map, a zone
of inadvertencies, unclaimed
 immensities within—

How can there be error?
How to stray when there's no destination?

And yet to embark in this or that direction
into pure undelimited space

is to forego other ways, to surrender
breadth to line.
 In that moment,

certainty is a useful delusion,
allowing a quick first stroke,

as when a bow parts the vastness
and leaves
 its wake on the delible surface:

lines cross lines, causing
disturbances, tangents and rare

contingencies—until those joys
of *or* and *or* and *or* and *or*
 like wind gusts,

give out or shift direction.
Then other pleasures hold sway a while—

calm, balance, voluptuous form.
You can moor there

in the harbor and listen
for dark's good counsel,

consult the stars and chart,
 if you want,
another farther course.

Cartography

If you don't know the way by heart you're lost.

The topo map, unfolded and folded so often,
is torn, rubbed sheer, almost transparent in places,

the slopes and ravines worn measureless.
Goldeneye and beardtongue blur in the shade

of an unmarked outcrop. Illegible fractures
and repercussions. Color, a slurry

of memory and pollen, obscures the border.
The legend is a washed-out gravel road:

there's no accounting for scale or random
hollyhocks leaning on fences. The sky

won't fit either, nor criss-crossing
jackrabbit paths, train tracks, lot lines.

A greater blankness encroaches. Time
tips on its side. Talus shifts underfoot.

Your landmark tree is erased in the glare.

Show Me an Angel

How to make the invisible
visible in

this space to open
the seen and disclose

from within
its boundaries the unseen

to expose to the eye
what is apparent

in mind
How not to believe but know

from the air itself
to unfold a wing

a dove
from the magician's scarf

without the scarf
or magician or

a fawn
from dappled ground

without the fawn
or ground

that undappled joy
as the animal

body appears
from what seemed

to be
nothing into form

but the thing is
it was there all along

Star River Night

It's not a falls
but a record of falling,

the river's
spill into empty

dark: drops
and splashes graph

in the aggregate scatter
a way;

the running over
isn't random but is,

within the structures and strictures
of the physical, free.

| | |

Gravity makes the image

| | |

One star—

a drop
in the River of Heaven,

a rush so unstinting it looks still,
can seem

to pulse,
to disambiguate from the sinuous

arching
body of light

it's a silver ingot of,
to be

somehow not itself
abstract,

but an actual
mote of fire,

a dense, literal seething.

Alma Thomas's "Orion" Is

by steadfast
refusal assertion
 She refused
to surrender to
concede
 She refused
to let
color be dimmed
her every mark sure
block after block
on fire
 She refused
to let
her one voice
be paled
here or her one
vision be narrowed
to narrative
premise
 She refused
to let Orion's line
of stars apparent
form among the random
distances be 'belt'
be anything less
than rest
in the scatter
 She refused
she would not
even seem to retell
the hunter's storied
swagger and sword
 She refused

for her Orion
to be mere
illustration one more
example of
'what men are like'
or what vengeance
sets in motion
 She refused
to do less
than see

"Spiral Leap"

A NASA simulation
 in fuchsia: the orbit
without the orbiter. Or

the spiral you draw on the air
as you whirl,
 encircled, your sparkler a wand

in your hand. Its fizzy light a line
 that leaps
when you think to leap,
that spells your name—

A line that stops,
 tucked back into darkness,

gone, as quick as fun. Used-up, bobbed,
burnt out like the mineral ice

that trails a comet
 across a passage of dark.

Motion and Cessation

The marks repeated
actions make
draw the body's

reach and symmetries
All the stumbles
and tossed-off

one-off gestures
averaged to abstraction—
Is it *life catching up*

with form? Or vice versa?
Remember how
the teacher

traced our shadow
portraits on the wall
one by one

we held stock still
each for our own
frozen silhouette?

If you laughed,
spoke, sneezed,
the teacher gripped

your chin, tipped
and turned your head
until you fit

inside the lines
of the image
she drew you into

She framed it for a goodbye gift

At Sea

At flood tide, the field goes under and the ocean unflattens its
 pale cold-killed grasses, re-animates the broken reeds, tugs at
 the puppet-strings of the heather.

Once it was summer and I lay face up in the dory, loosed the
 lines, and let the tide decide.

Six gulls, an osprey, a little flotilla of cormorants—air, sea—
 who isn't afloat in lapses of drift?

| | |

At dead low, there's nothing to puppet the limpness, no fingers
 to fill the empty gloves of the marsh.

Left behind, refused by the tide—torn seaweed and plastic, a
 scatter of shells, gravel, winter-bleached trash—stuff there's
 no use denying.

Smoke blooms on the next point—a neighbor burning storm-
 splintered wood—a boat, it looks like, but who burns a boat?

Night Forms

1
No one stood
on a rocking deck
chill and salt lifting off

skiffed water
invisible

lives coursing beneath
The subject is not the subject
All surface

these pencil grays
but not as skin

is the surface of a body
There is
there never was a body

Are we even meant
to think of the sea?

Meant to or not
what we see is *ocean*
as when a child sees

a horse
she says neigh

2
What looks like empty sky
somewhere left

of the moon—
 the black-pencil flank of Pegasus
myth foaled from blood and sea foam

Or is that dark the starless
gap under Cygnus' orphic wing?

The great stories name the brightest lights
plot points
 heroes and villains

The flesh of the tale is darkness
or what looks like dark
 to the naked eye

Night Vision

When I was a child, I saw what I called angels among the trees. The angels drew me. I loved them because they appeared only to me. They belonged to me. I didn't think to be afraid. I loved them because they appeared. They were tall, translucent, and fluttered like torch flames. I knew to tell no one. I surprise myself by telling now. The silence around and within them swirled with a furied longing to speak. They were mute. They only appeared. They drew me. Often I walked out at night. I didn't think. I loved. I saw as one sees by torchlight, by knowing already what's there to see. They appeared tall as torches and fluttered. They longed to speak. I knew to tell no one. I was a child. They drew me. The silence among them swirled translucent. By telling now I surprise myself. Angels I called them because I loved them. They were tall.

"Femme-Maison"

With her head in a house
and her hand in a hand
she stands, a dwarf
on tiptoe—

not falling by virtue
of leaning, not held
by reason to account:
no one

expects of the hooded
sight or progress.
What a relief
benightedness

is. Inside her
head-house,
a one-room shotgun
shack,

shrunk up soft
like a dumb
untempted phallus,
she thinks on

in near red
silence, weaving
one-handed (she
holds the shuttle

in her teeth),
singing but low,

so the sound
can sound

like wind,
tuneless across
the chimney
of an empty house.

Irascible

Approval pays for light and space—

walls and lockable door
high windows that tipped open
shift the hovering
 in-motion shadows—
yet what it says
 "one admires…"
 "such fine…"

contracts
 (or seems to)
possible travel
to one worn path—

one way concurrence
the other way spite—

an off-kilter line-graph of fear
cut through what once had been
unknown
 untried ground

Praise is too easy to crave and worse to believe—

What entrances
me is what cannot be entrapped

The Wall

While we slept, a palisade rose up around our house—high narrow trees nailed side by side, espaliered against whatever's behind them. The trunks stand so close together that their branches had to be lopped off. No leaves, no fruit. Except at noon, when the sun hangs directly overhead, within the high doorless walls dusk overshadows day, a day-long dusk that soon narrows to night.

The wall keeps the outside out and inside in, theirs there, ours here. No trespasses to punish or forgive. Climbing is absolutely forbidden. Ignorant squirrels and badly parented children, sometimes—it can't be helped—die trying to cross over. Flying birds have flown away.

Even so, we have our compensation—a nice assortment of pretty finches, cardinals, an indigo bunting or two—no dull sparrows or obnoxious crows—set here and there along the wall. Our versions of the birds hold still so we can see them whenever we like, charming in their various poses and considerate in their quiet. We thought we heard one the other day—or was it a child calling from the other side? We must not approach the wall, no matter what we hear from beyond it.

We had supposed the rain and dark were meted out equally, that the wind blew just as hard and soft on both sides of the wall, but look! Their sky this noon is clear, while that saggy, sodden, wayward cloud, their side's cloud, is crossing over to rain on us There ought to be a law.

Fire

As insubstantial as dream, which is nothing without its dreamer, fire is powerless alone.

We can, and we love to, contain it within a circle of stones. Seated around it, we'll watch as it flutters and leaps, seethes and glowers. We'll listen for hours to its mumbo-jumbo, feeding its pretty light. Then when we're tired of its antic or solemn presence, we have only to deny it form, and it goes cold. In winter we enclose it in our homes and let it warm us.

If it were not for error, stupidity, or malice, or the skeleton fingers that storms poke down into our midst, we wouldn't, and would have no reason to, fear it.

Whatever object fire inhabits and in habitation consumes—whether it's a miles-wide tallgrass prairie, a star, or a pittance of candlewick—it is almost utterly dependent on that object. Without access to air and something to burn, it retreats into theory. Which is not to say it is harmless, of course. Only a fool believes it is only the material that does material harm.

Some say humans stole fire from the gods, others that it escaped from the realm of the dead. Whatever its provenance, fire is endemic now. It burns. It bursts unbidden from the mouths of martyrs and children, lolls red off the tongues of white-throated sparrows and green from the arched fronds of solomon's seal. It spills its seed like blood and casts its spores to the wind.

One night, you will wake as its prophet and feel its pulse throb in your veins. Are you enough to contain it—your body its limit, its circle of stones? Or will you succumb and become it—it and its aftermath of soot?

After the Burning of Flood Christian Church in Ferguson, MO: An Exploded View

She'd winch up the shards || to abstract from the ruin form.

Each piece suspended, || lifted out of the noise

On its own invisible wire, || italicized and counted, singled

Out for re-assembly. || Arson undid them all—

All the pieces—almost || equally. The artist (imagine her

In rubber boots and yellow || mackintosh, shaking off the rain)

Would retrieve what she chose || from the wreck and char: brass

Bells, *By the rivers of Babylon*, || glass shards, a flattened silver-

Plated plate, a cut-glass || earring, riffles of ash-

And gold-edged pages, dog-ears || and thumb-smears, rests, half-

Notes and time signatures, || the warped candle snuffer,

The image of God as a rock, || a hen, fire, an anchor,

A word, a man, a potter || with clay under her nails,

Pink-flushed puffs of fiberglass || insulation, keys, a copper

And verdigris elbow of pipe, || the choir's drawn breath

Before its first anthem, || *the words of our mouths and meditations,*

The stink of burnt foam-rubber, | | ozone, tobacco, and sweat,

A bullet cast from melted | | trumpet brass, easy

Sleep, a cymbal and clang, | | clang, clang, clang ...

(How long can this listing | | and winching go on? Not

Seven but seventy times | | seven wrongs and forgivens,

Hundreds of ingots of lead, | | hang in the air, a sooty

Cloud of witnesses, pending | | storms. Can you see it now?)

How can we sing | | bent notes, a bent

Cup turned upside down, | | *We hang our harps in the willows*

Raze, raze, remember, | | *my chief joy,* my son,

Head dashed against | | *a stone. May the words*

Mouth, heart, harp— | | *Turn to Psalm 137.*

There we sat down | | *and remembered* Michael Brown.

The Melancholy of the Actual World

If I unstitched this muslin doll, my body,
pulled out the rag-tag stuffing,

would I discover it there, under
the red corduroy heart or caught

like lint in the furred ribs? If I unwove
the cloth to a pool of kinked thread,

the over-and-over scribbles and loops
of a child practicing her letters?

If I set that unwound, unmade
material of the material on fire,

would the unraveling smoke
or the sharp scent of burning resolve

then to an irreducible, like zero, or ?

Why Seek the Dead Among the Living?

As hollow as a gutted fish, a hole in the sand,
A cistern cracked along the seam—

There is no filling such emptiness. And yet—

Stitch it shut. Pour and pour, if you wish. Wish and wish, but
 it's wasted—
Water carried to the garden in your cupped palms.

Might as well seal an ember in a wax jar. Kindle fire on the
 crest of a wave.

Unbloom a poppy, reshut its mouth, unred its lips—
As if it hadn't already sung,

As if its voice hadn't already set all summer singing.

And the gall at its throat, the boil it's prized for,
Hadn't been cut and bled of its white sleep.

As if a child could be folded, resewn in its sac, and returned to
 its womb.

'It Remains to Be Seen'

Unable to look any longer
at any more certainty,
swagger, and grandiloquent
weight however sublime.
Such a preponderance
of solemn forms.

We went outside,
coffee and napkins
in hand, to rest
under the trees,
to listen, to let
we thought nonhuman
voices wake us

from the minimal
immensities inside.
But stop—
those calls are not
the birds'. I hear
language in the squawks:
boys. Beuys.

Quick and Still

Little one
 finch in the thistle

smidgeon pin-
 feather

borne on the wind
 as if wayward

light
 as a scruple

of pounded gold
 a shred

of mylar
 ash-dredged spark

catch
 hold

weave your nest
 a hollow

the size of a child's
 cupped hand

or her first
 spoken word

stay
 there in the tulip tree

we love
 don't

please
 unless

until you must
 flit away

Seismography

When the mind moves
 testing its quick
flits feints
 reversals

its dizzied or
 downward
 backward glances

the hips stay
 counterposed

set as stable

as a plank across a marshy place
to drier leaf-strewn ground

Here
 in the thrush and phoebe
 almost spring

the mind might rest
in the clearing quiet

itself
to a low hum

one note
 an open string
 responsive

not listening

so much as trembling

on the harmonic wave
 the way

the scribal needle draws

its shivered seismic line

The Coriolis Effect

A moonflower vine lifts and wobbles in midair,
Seeking leaf-hold by leaf-hold the moon.
This is a vine whose flowers are meant

To brush the matte, frazzled wings
Of moths in late summer. Dark
Stirs up a quick white cyclone

Of lives all turning
As if about a nether axis.

As if about another axis
of lives, earth's turning

Stirs up a whole slow cyclone
Of butterflies in early light, sheen
To brush the dazzling, azure wings

Of a flower whose vines are meant
To seek leaf-hold by leaf-hold the sun.
A morning glory vine lifts and wobbles in midair.

"Uninvited Collaboration"

Torn under the weight of rain,

a flustered moth, or some unnamable

inadvertency, the spider's fine tatter

drags, unhitched a while—
 its ragged

at-loose-ends-ness—the image of—*is* it

damage the way the silk lists

and lofts, shivers and warps, its unbound

strands all differently
 responsive—

Is it useless as is? A broken dream-

catcher at the window? Unfixed and uneven,

one hemisphere wefted taut,

alert to incursion, while
 the opposite

drifts and droops, alive with disturbance,

an unkept record of the pulse and impulse

of wind or whatever else happens—

Afloat

what is it to surrender
purpose to sway
to re-ambiguate
let miscible edges blur
hold shadow in shade
air in air almost
dissolving
into undulant
transparence & all
but vanish in the breathing
uncontained uncontaining
motion all
there ever is
& shifting
like one in a swarm of
medusae
like in like
almost visible drifting
a part
of the current wherever it flows

Whole Cloth

As in spring the winter
rye is turned

its cryptic underside
the source text

made legible
or as when in fall

flax-straw is turned
back to billow

the linen fibers
scutched and pummeled

to thread and dyed
for the loom for the weaver

who caught up in
the pleasure of vanishing

into the work the shuttle
the felted thump

of the beater against
the weft turns

immensities of sensation
a skyful of vaporous

air and ice
to thunder to sudden

downpour a swath
of material blue

"Cranoch Glen"

where even the sky
would lie down
to take its rest
in smallness

these scaled-down
hills a re-enactment
of long-rained-on
goat-bitten

steeps and sheer
cliffs rubbed patient
eased with patchy
green and we like

to think wild
violet and cinquefoil
incursions
in the turf where wind

would spend its last breath
were it allowed
to stop to curl up
among

the living fill
the grass bowl
a hollow place
paved with stones

a cistern of quietness
a tree-less glen
the size of a body
a human body and an idea

Looking

through head-high parens:

close mown ground,
leafed-out trees, a patch

of managed northeastern woods,

we saw the moment for a moment set apart—

not as much seeing as seeing through

and by virtue of its lens,
(an upturned, upright

eye) ourselves.

| | |

Looking back through

from the aperture's other side
with the trees behind us

we saw through its gates
open ground and above

a contrail (ice and aircraft exhaust)

passing, a slow parade
from sky

into *5 PB 7/8 blue*
and back again

into re-realed scatter-light sky.

"Character Set"

The fog a bleared
window is a mirror

An inward looking glass
returning gray for green

for glance and gaze
blank stares

One's very image morphed
in its mute whites

to a lemma of
not the thing itself

Unembodied for
an interval of hours

out of that cloud of almost
recovered unknowing

an alphabet of silhouettes
A lexicon made gradually

legible an upstroke
downstroke branch

a bramble calligraphs
of other houses

A ladder leant against a wall
stakes at the property line

Not only what's closest appears
and like premonition

behind the tipped and upright
stalks a sort of sunlight

The Provenance of Color

A fox glances back
and vanishes over the rise

her lovely copper undulant run
burnished in retrospect Yet

consider as well the stink
of her muzzle matted

with blood and her expert stealth
and so the shades

and forms shift
in your mind not negating or erasing

the translucent
pink around her body as she disappeared

but grounding that light
with a peaty root-woven sop

weight cut wet
from the earth and stacked for burning

Black on Black

She unearths a dark
left fallow for years and sifts

for whatever luck has dropped there—
iron nugget, button, nigella seed.

She enters the darkness to mine
for darks—lacquered and glassy,

penumbral and stark,
lusterless coal, oil slick, tar...

What she can't take by excavation,
she steals by fire. Burning

unwinds from things
their sunlight, releasing carbon

explosions at the fuse end,
streaks and accidents of char

and sugar—spirals
of black on black.

Sea and Grass

She walks along the edge
where grackles peck at the dirt

corrugations They are robbing
seed from an ocean

In her mind's eye the green
waves already crest and trough

If she stopped thinking of the sea
it would nonetheless rise up

on its own momentum becoming
grass The tips of the blades

will translate the wind
more unlike than like

an ocean the birds lift
in waves as she goes by

and afterwards resettle

Afterword

Is abstraction
 like the view,

say, of the salt brook at out-going low
(a shallow helix of ochre reflections,

clarity
 moving over the stones)

or at high in-coming tide
(a scrum of green opacity

flushed with rust and tumbled
 sand

except endless, edgeless, shadow- and sunless)?
You'd have to subtract the things,

salt stone rust sand
 the motions and causes,

any depictions from memory
square bridge cone house

What's left
 then but the dark—or rather—darkness?

| | |

I like to think on darkness
and the fire that rides the air
 around a burning wick—

how it floats and shivers, dragged down a little:

gravity distorts the light
(even the light!)
 to the shape we agree to call flame.

Notes

The poems in *A Gray Realm the Ocean* were all written under
the influence of art—specifically, abstract visual art by women.
Although all these poems were, of course and as usual, affected
by other poems and poets, each was also written in response to a
particular artist's work. Sometimes, I had in mind one painting,
print, sculpture, weaving, or performance, but whenever possible
even then I was also thinking of the body of work. These notes
will cite titles when that's appropriate.

I hope, dear reader, that you will feel moved to look (again)
yourself! I am deeply grateful for the example, the instruction,
and especially the deep pleasure that these artists have given me.
I only wish I could have included more of them here.

EPIGRAPHS

Vija Celmins wrote in her notebook, "My eyes were honed in
nature. I practiced seeing the desert." Chuck Close then quoted
the passage back to her as part of his interview with Celmins:
www.artspace.com/magazine/interviews_features/book_
report/chuck-close-in-conversation-with-vija-celmins-about-
her dense yet infinite-drawings-54732.

Jennifer Bartlett said, in an interview with Elizabeth Murray
(in *Bomb*, October 1, 2005), "I don't know what they mean [by
abstraction]. I don't know what they're talking about." Just
before that, her conversation with Murray went like this:

JB: That's the only thing I could never figure out, what
 figurative meant. If a painting is white with a red square
 in the center—
EM: That's the image.
JB: It's a red square. That is a thing. That is just as figurative
 to me as a blooming peony. I've never been able to make
 the distinction in my mind.

EM: What exactly people do mean by abstraction.

JB: I don't know what they mean. I don't know what they're talking about.

POEMS

Incognita, Agnes Martin. The Agnes Martin lines (from a poem not quoted in full) borrowed for the epigraph are taken from the exhibition catalog, ed. Suzanne Delehanty (1973; repr., Philadelphia: The Falcon Press, 1976), 40. Martin read them as part of a presentation at Skowhegan School of Painting and Sculpture in Skowhegan, ME. The poem is dedicated to Jeff Hamilton who first alerted me—nearly 30 years ago—to Agnes Martin's writings.

Spirit Level, Agnes Martin

"Night Sea," Agnes Martin, "Night Sea"

Like Somewhere in Saskatchewan, Agnes Martin, "Flower in the Wind"

She Would Not Say Her Work is the Work of Turning, Agnes Martin, "The Rose"

"Lemon Tree," Agnes Martin, "Lemon Tree"

"Milk River," Agnes Martin, "Milk River"

Sufficing, Agnes Martin

Abstraction, Agnes Martin

Reading Nautical Maps, Helen Frankenthaler, "Dream Walk"

"Mountains and Sea," Helen Frankenthaler, "Mountains and Sea"

"The Bay," Helen Frankenthaler, "The Bay"

'Womb-of-All, Home-of-All, Hearse-of-All Night,' Helen
Frankenthaler, "Warming Trend." The quotation is from
Gerard Manley Hopkins's "Spelt from Sibyl's Leaves."

A Clear Jar, Helen Frankenthaler, "Basque Beach"

White, Joan Mitchell

"La Grande Vallée XIII," Joan Mitchell, "La Grande Vallée XIII"

"Sunflower III," Joan Mitchell, "Sunflower III"

Sub-Linguistic Mumbling, Amy Sillman, "Split 2, 2020." The
poem's title is drawn from this statement by the painter:
"Painting is a physical thinking process to continue an interior
dialogue . . . a way to engage in a kind of internal discourse,
or sub-linguistic mumbling." Amy Sillman (Artnet or Saatchi
Gallery, www.saatchigallery.com/artist/amy_sillman)

Interior 1963, Elaine de Kooning, studies toward a portrait of
John F. Kennedy. The poem is dedicated to my mother, who
is and always has been there with her love.

If, Emmi Whitehorse

Cartography, Emmi Whitehorse, "Ginger Wood 2"

Show Me an Angel, Dorothea Rockburne, "White Angel #2."
The title is taken from Courbet's famous statement: "Show
me an angel and I'll paint one," a statement Rockburne said
she was responding to with her piece.

Star River Night, Pat Steir, who has often been quoted as saying,
"Gravity makes the image."

Alma Thomas's "Orion" Is, Alma Thomas, "Orion"
"Spiral Leap," Elizabeth Murray, "Spiral Leap"

Motion and Cessation, Heather Hanson, "Emptied Gestures"

At Sea, Bridget Riley

Night Forms, Vija Celmins

Night Vision, Louise Bourgeois, "Personnages"

Femme-Maison, Louise Bourgeois, "Femme-Maison"

Irascible, Hedda Sterne. Her full sentence was, "What entrances
 me in art is what cannot be entrapped in words." (The
 statement is widely quoted.)

The Wall, Louise Nevelson, "Tropical Garden II"

Fire, Marina Abramovic, "Rhythm 5"

*After the Burning of Flood Christian Church in Ferguson, MO:
 An Exploded View*, in the manner of Cornelia Parker's, "Cold
 Dark Matter: An Exploded View"

The Melancholy of the Actual World, Ann Hamilton

Why Seek the Dead Among the Living? Ana Mendieta

"It Remains to be Seen," Louise Lawler. The poem title is also
 the title of her 1987 exhibition at Metro Pictures, a show she
 deemed "as serious as a circus." The piece I reference here
 is "Birdcalls/1972–1981," a courtyard installation at DIA/
 Beacon NY.

Quick and Still, Mary Abbott, "All Green." This poem, as well as the book, is dedicated to my granddaughter, Karlyn.

Seismography, Jill Moser, "Cycle X"

The Coriolis Effect, Carmen Herrera, "Tondo: Black & White II"

Uninvited Collaboration, Nina Katchadourian, "Uninvited Collaboration: Spiderweb #14"

Afloat, Ruth Asawa

Whole Cloth, Polly Barton. The phrase "condensation of sensation," torqued a bit here, is from Henri Matisse, "Notes of a Painter," 1908.

"Cranoch Glen," Beverly Pepper, in memorium. Laumier Sculpture Park, Kirkwood, MO

Looking, Chakaia Booker, "A Moment in Time," at Storm King Sculpture Park, Mountainville, NY

"Character Set," Melissa Meyer, "Character Set"

The Provenance of Color, Annie Albers

Black on Black, Maria Martinez

Sea and Grass, Maya Lin, "Storm King Wavefield," at Storm King Sculpture Park, Mountainville, NY

Afterword, Jennifer Bartlett

Acknowledgments

I am grateful to the editors of the following journals who first published these poems, often in quite different earlier versions and/or with different titles.

Beloit Poetry Journal, "After the Burning of Flood Christian Church in Ferguson, MO: An Exploded View," "Alma Thomas's 'Orion' Is," "Spiral Leap"
Bennington Review, "Like Somewhere in Saskatchewan," "Reading Nautical Maps"
Chronicle of Higher Education, "Lemon Tree"
Cimarron Review, "A Clear Jar," "Cranoch Glen"
The Cincinnati Review, "Grande Vallée XIII," "Sunflowers III," "Womb-of-All, Home-of-All, Hearse-of-All Night," "Why Seek the Dead Among the Living?"
Copper Nickel, "White"
december, "The Provenance of Color," "Sea and Grass," "Night Forms," "Night Vision"
Field, "Interior, 1963"
Free Verse, "Mountains and Sea," "Night Sea," "Sufficing"
humana obscura, "At Sea"
Image, "The Bay"
Interim, "Character Set," "Incognita"
Kestrel, "Whole Cloth," "Spirit Level"
So To Speak, "Milk River"
Sou'wester, "Femme-Maison"
Spacecraftproject, "Quick and Still"
Tupelo Quarterly, "Whole Cloth"

And to *Poetry Daily* for reprinting "White" and "Why Seek the Dead Among the Living?"

I am very grateful to Patricia Spears Jones, Elizabeth Frost, Richard Morrison, Tim Roberts, and everyone at the Poetic

Justice Institute at Fordham University. I am also thankful for the close and generous attention of all my readers and colleagues, especially Jen Daniels, Allison Funk, Heather Green, Jeff Hamilton, Sally Keith, Emily Lu, Melanie McCabe, Eric Pankey, Chris Perkowski, Jason Sommer, Peter Streckfus, and Emily Tuszynska. Let me also add thanks to my students, whose quickness of mind has delighted me all these many years.

Jennifer Atkinson published five books of poetry before *A Gray Realm the Ocean*, most recently *The Thinking Eye* and *Canticle of the Night Path*, both from Free Verse Editions / Parlor Press. She is recently retired from George Mason University, where she taught in the MFA and BFA programs in Poetry Writing. She lives in northern Virginia.

Patricia Spears Jones is the author of five books of poetry, including *Painkiller*, *Femme du Monde*, and *The Weather That Kills*. Her work has been featured in numerous anthologies, including *Angles of Ascent: A Norton Anthology of Contemporary African American Poetry*; *Starting Today: 100 Poems for Obama's First 100 Days*; *Black Nature: Four Centuries of African American Nature Poetry*; and *Best American Poetry*. She has taught at LaGuardia Community College and Queens College CCNY, Parsons, The New School, and the College of New Rochelle

POETS OUT LOUD
Prize Winners

Jennifer Atkinson
A Gray Realm the Ocean

Alison Powell
Boats in the Attic

Stephanie Ellis Schlaifer
Well Waiting Room

Sarah Mangold
Her Wilderness Will Be Her Manners

José Felipe Alvergue
scenery: a lyric

S. Brook Corfman
My Daily Actions, or The Meteorites

Henk Rossouw
Xamissa

Julia Bouwsma
Midden

Gary Keenan

Rotary Devotion

Michael D. Snediker

The New York Editions

Gregory Mahrer

A Provisional Map of the Lost Continent

Nancy K. Pearson

The Whole by Contemplation of a Single Bone

Daneen Wardrop

Cyclorama

Terrence Chiusano

On Generation & Corruption

Sara Michas-Martin

Gray Matter

Peter Streckfus

Errings

Amy Sara Carroll

Fannie + Freddie: The Sentimentality of Post–9/11 Pornography

CPSIA information can be obtained
at www.ICGtesting.com
Printed in the USA
JSHW061125210922
30752JS00009B/21